The Lord Is My Shepherd

THE TWENTY-THIRD PSALM

Illustrated by
Tasha Tudor

PHILOMEL BOOKS
NEW YORK

Library of Congress Cataloging in Publication Data
Bible. O. T. Psalms XXIII. English. Authorized.
1980.
The Lord is My Shepherd:
The Twenty-third Psalm.
SUMMARY: Presents an illustrated version
of the twenty-third Psalm.
[1. Bible. O.T. Psalms XXIII] I. Tudor, Tasha.
II. Title.
BS1450.23d.T8 1980 223'.205203 79-27134
ISBN-0-399-20756-2

The Lord Is My Shepherd
THE TWENTY-THIRD PSALM

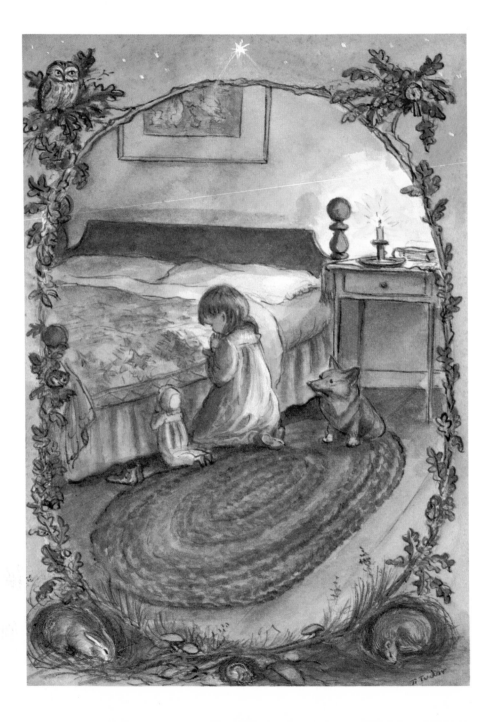

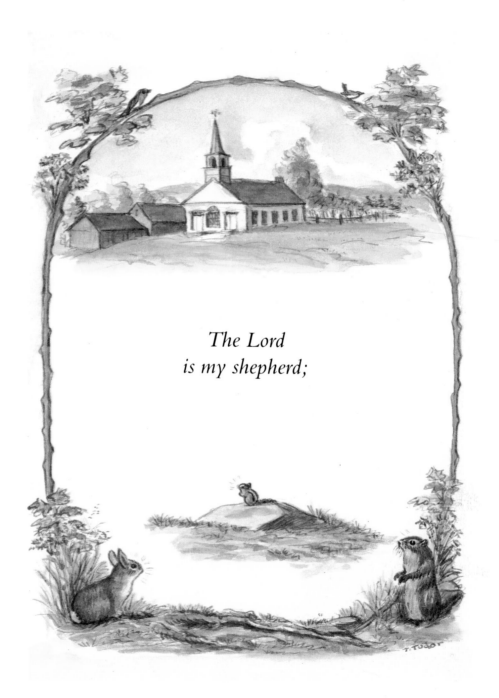

*The Lord
is my shepherd;*

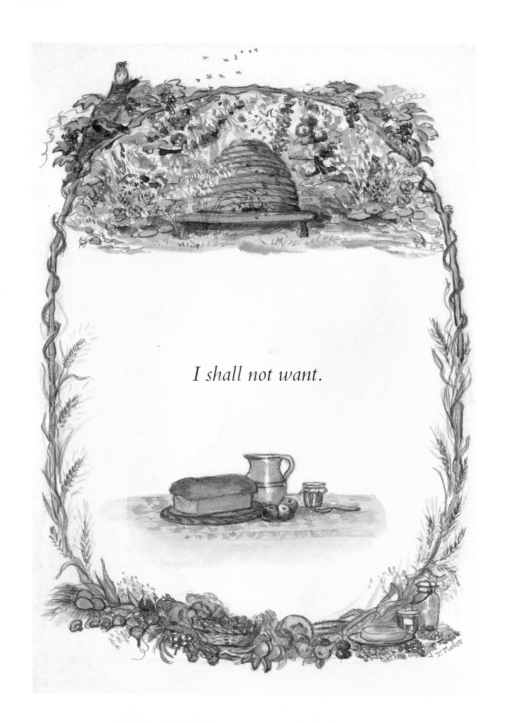

I shall not want.

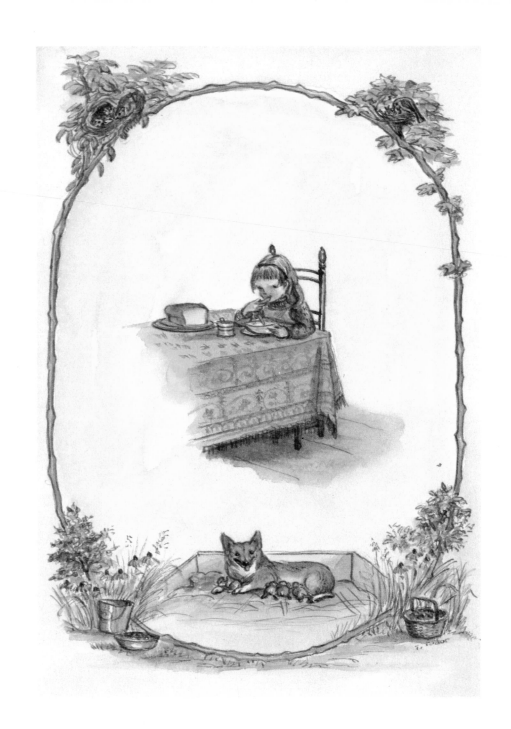

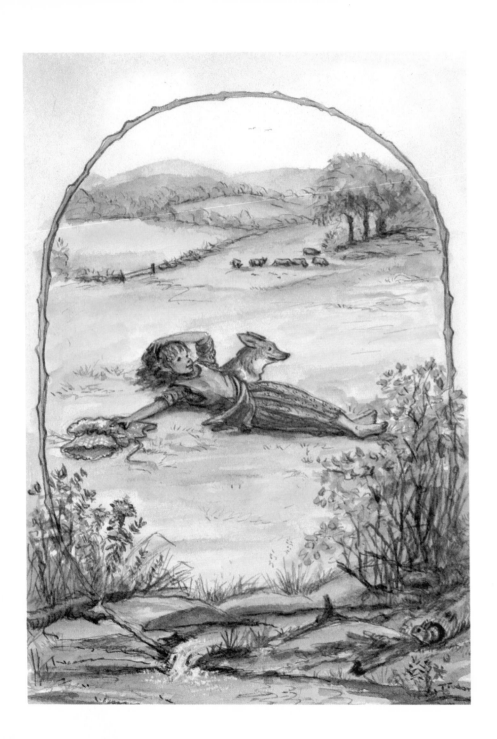

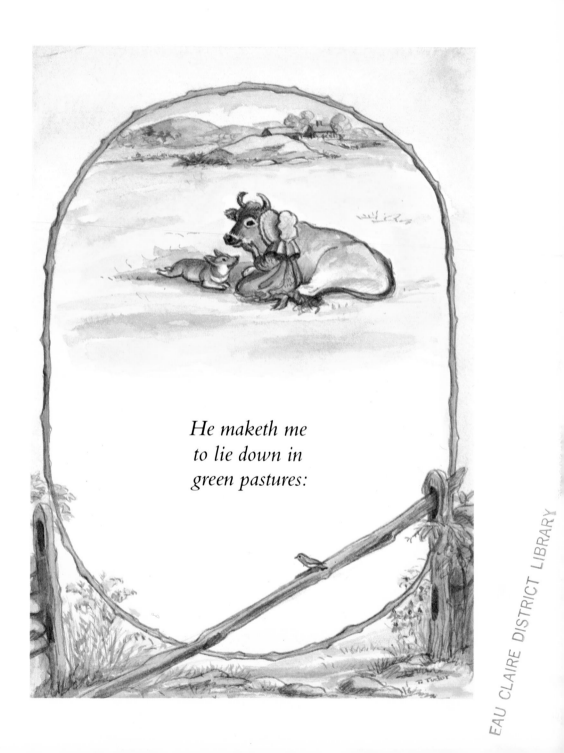

He maketh me
to lie down in
green pastures:

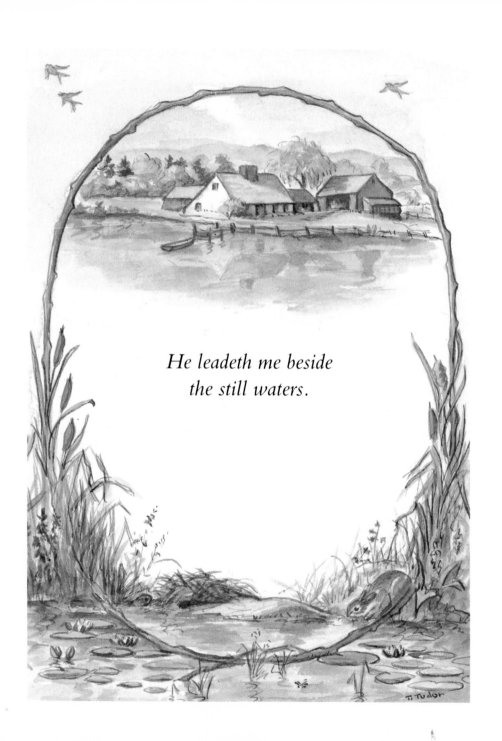

*He leadeth me beside
the still waters.*

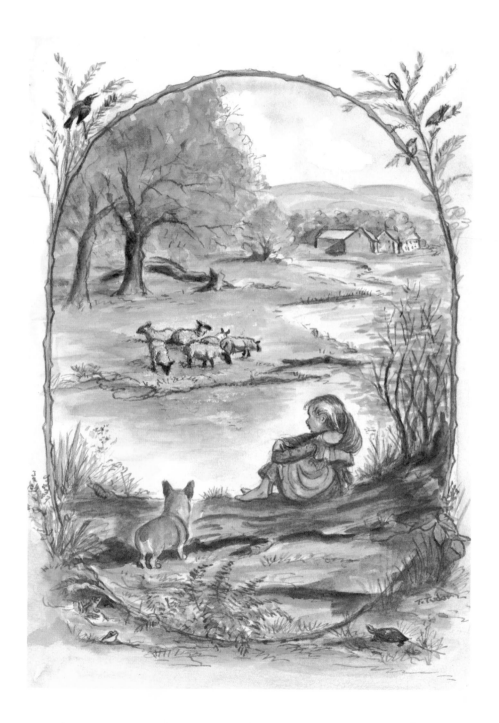

He restoreth my soul:
He leadeth me in the
paths of righteousness
for his name's sake.

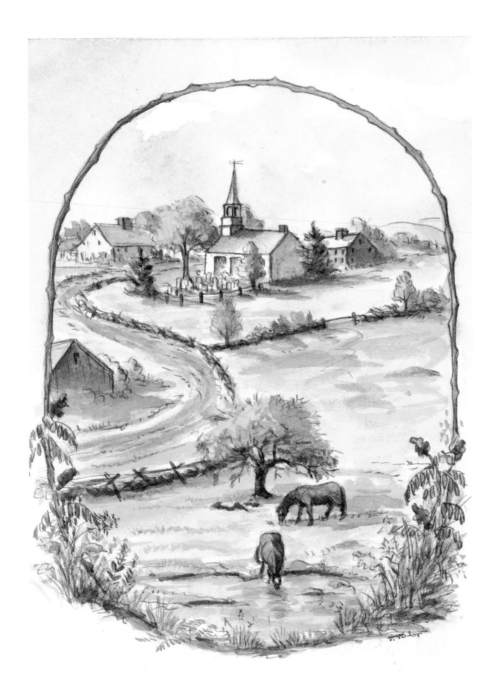

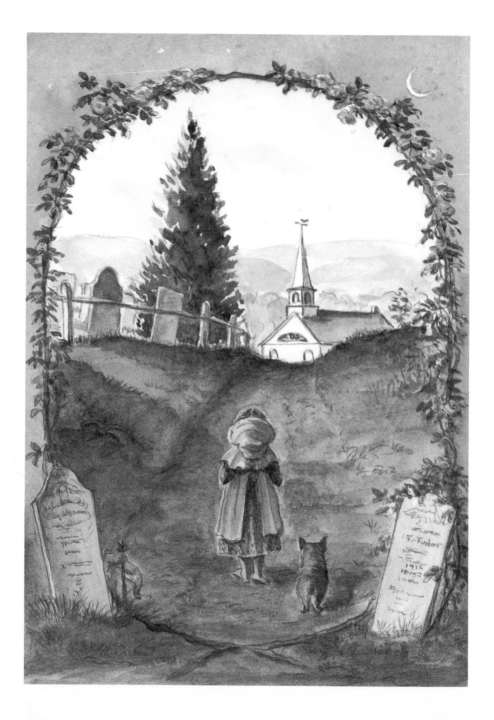

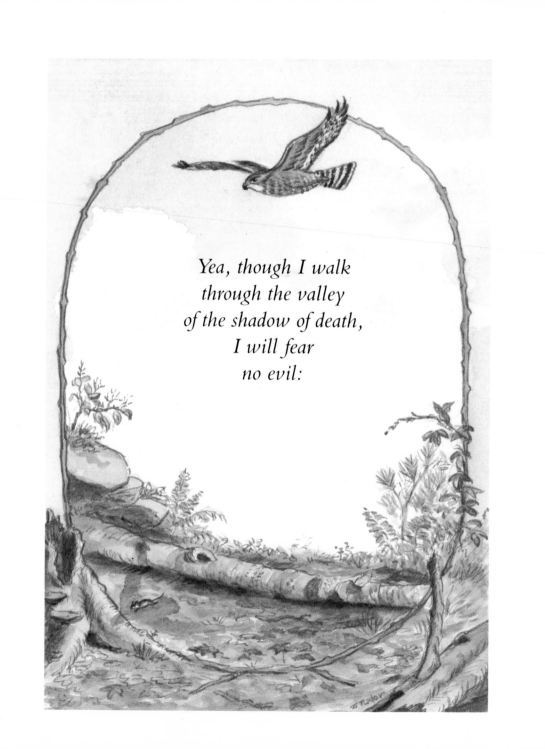

Yea, though I walk
through the valley
of the shadow of death,
I will fear
no evil:

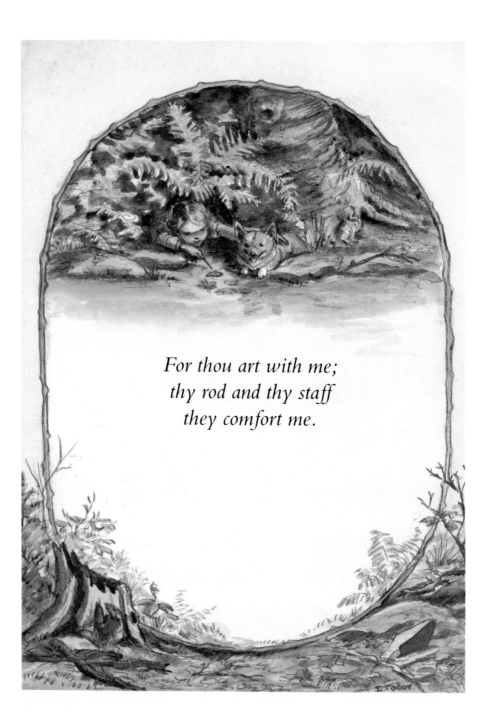

For thou art with me;
thy rod and thy staff
they comfort me.

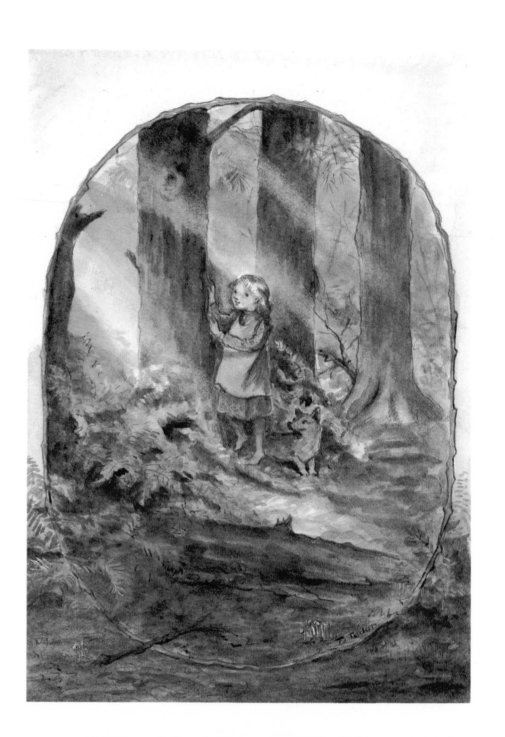

Thou preparest a table
before me in the presence
of mine enemies:

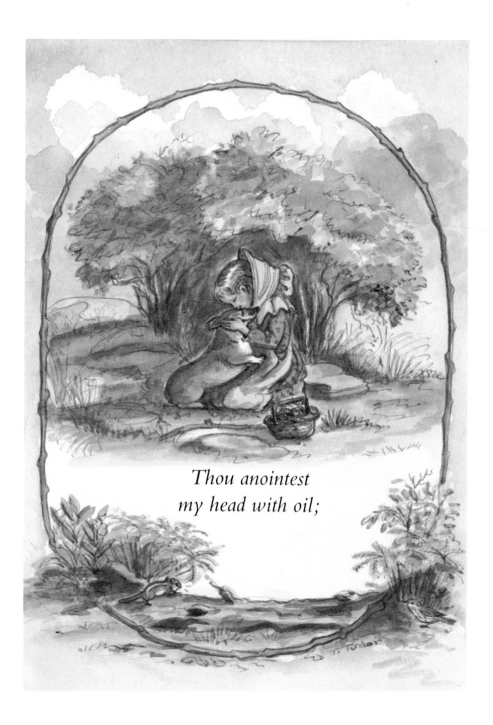

*Thou anointest
my head with oil;*

My cup runneth over.

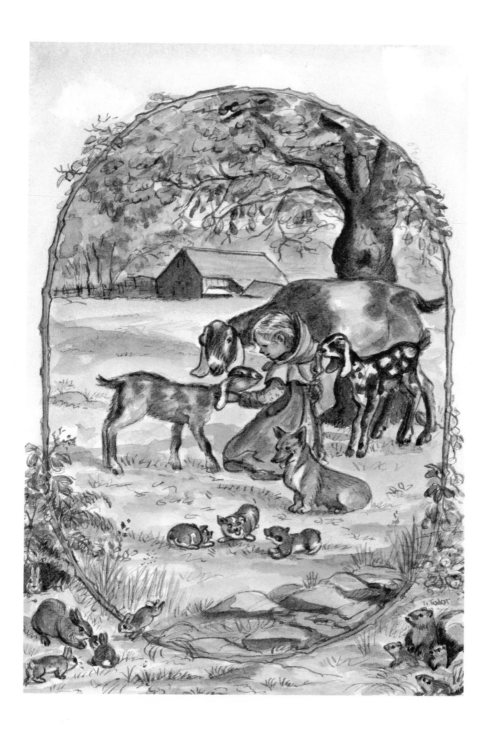

Surely
goodness and mercy
shall follow me
all the days of my life:
and I will dwell
in the house
of the Lord
for ever.

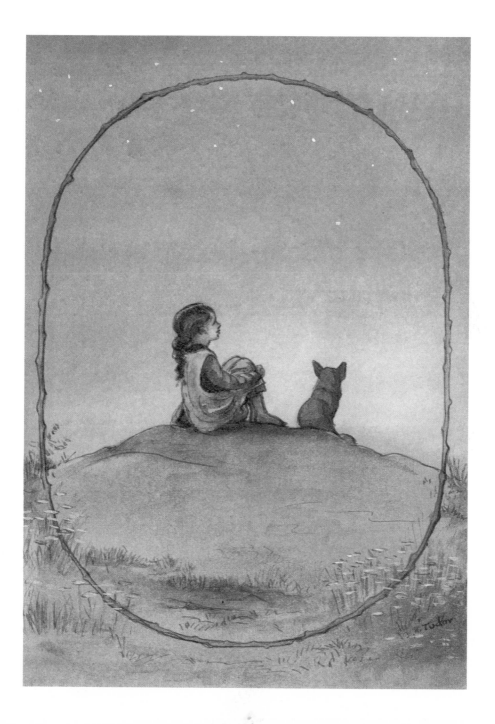

About the Twenty-Third Psalm

The Twenty-Third Psalm is probably the best-known and best-loved of all of the one hundred and fifty poems that make up the Book of Psalms, whose Hebrew name is "The Book of Praise." Almost every aspect of our relation to God is the subject of one or another of these works, written more than two thousand years ago. The special sense of serenity and simple trust, and the conviction that the world is in the hands of a loving God have made this psalm, which is one of the group written by King David, particularly appealing. The wording of the King James Version has never been surpassed in the English language, and it is this translation of the Twenty-Third Psalm that Tasha Tudor has chosen for this book.